NOSFERATU'S CHRISTMAS IN NEW YORK ©2016 Robert Jiménez

All rights reserved. No part of this work may be reproduced or transmitted in form or by any means, electronic or mechanical, including photocopying, recording, or by any information storage or retrieval system, without the prior written permission of the copyright owner, exempting for book reviewing purposes.

All contained herein was written and illustrated by Robert Jiménez. All characters appearing in this work are fictitious. Any resemblance to real persons, living or dead, is purely coincidental.

Robert Jiménez
P.O. Box 260491
Pembroke Pines, FL 33026

www.zerostreet.com
www.tikitower.com
www.strangewise.com

ISBN-13: 978-1540334855
ISBN-10: 1540334856

The images in this book are printed single-sided so as to prevent colors bleeding through. However, we still recommend using a sheet of paper in between pages while coloring, especially when using markers!

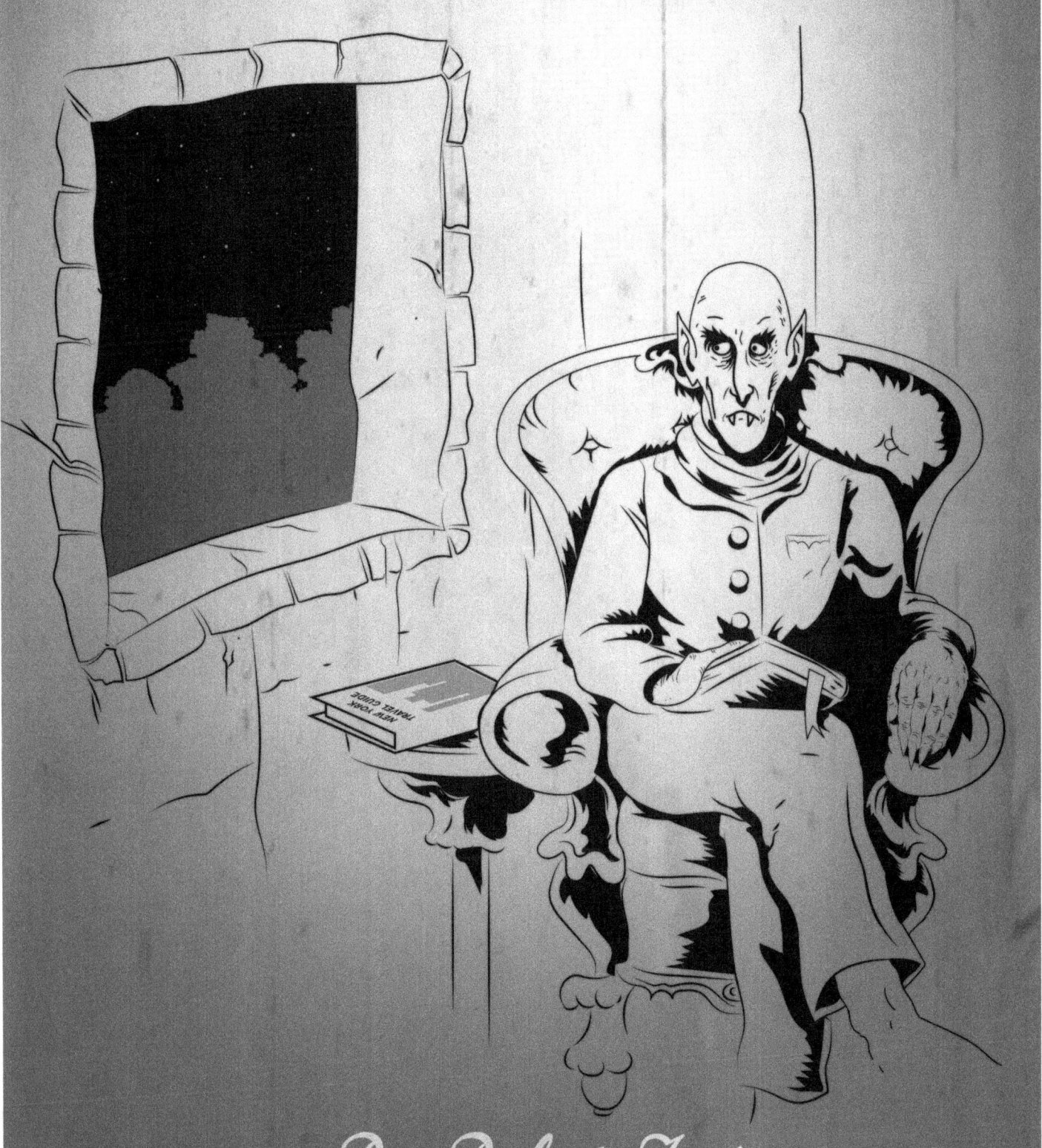

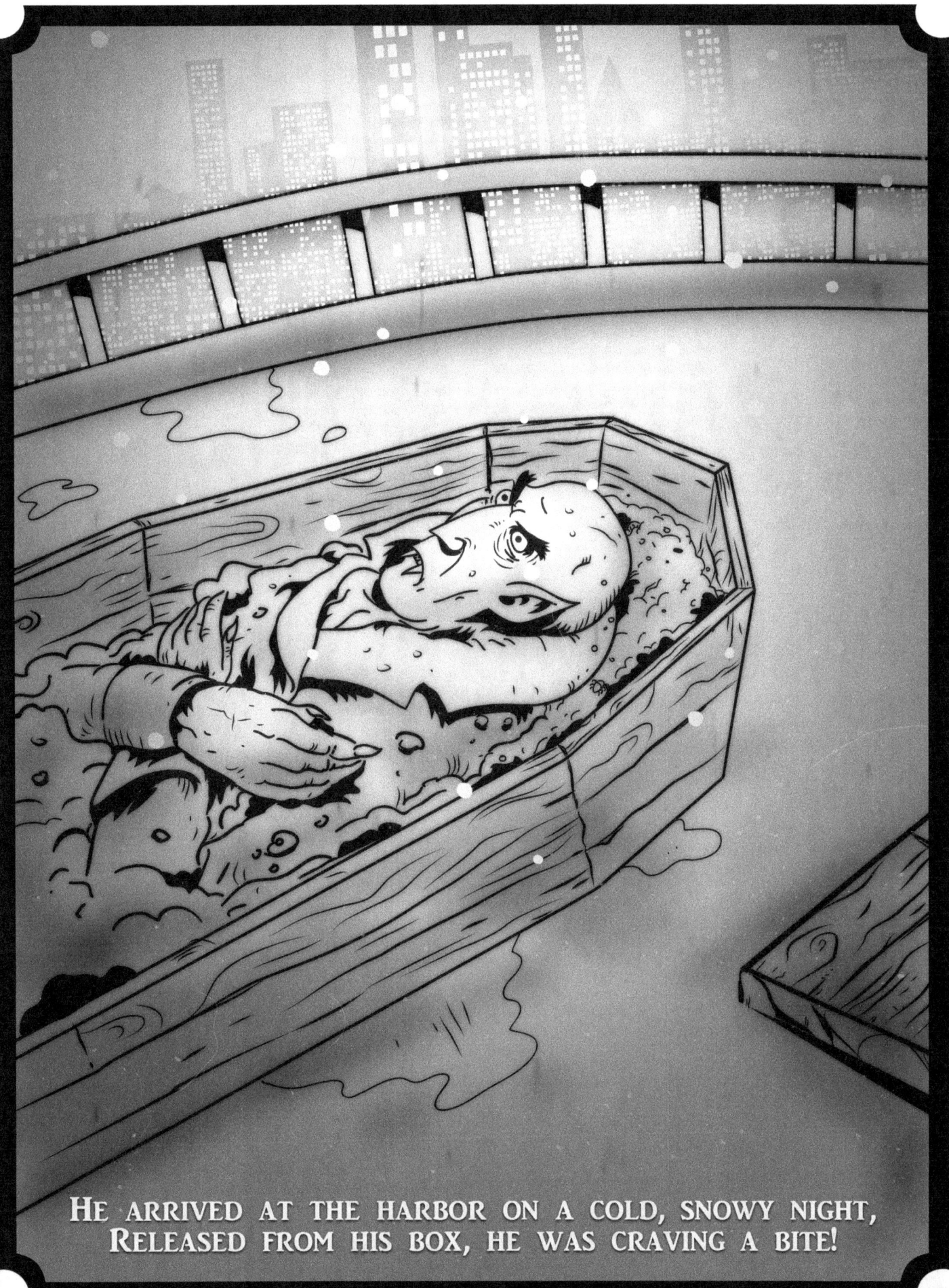

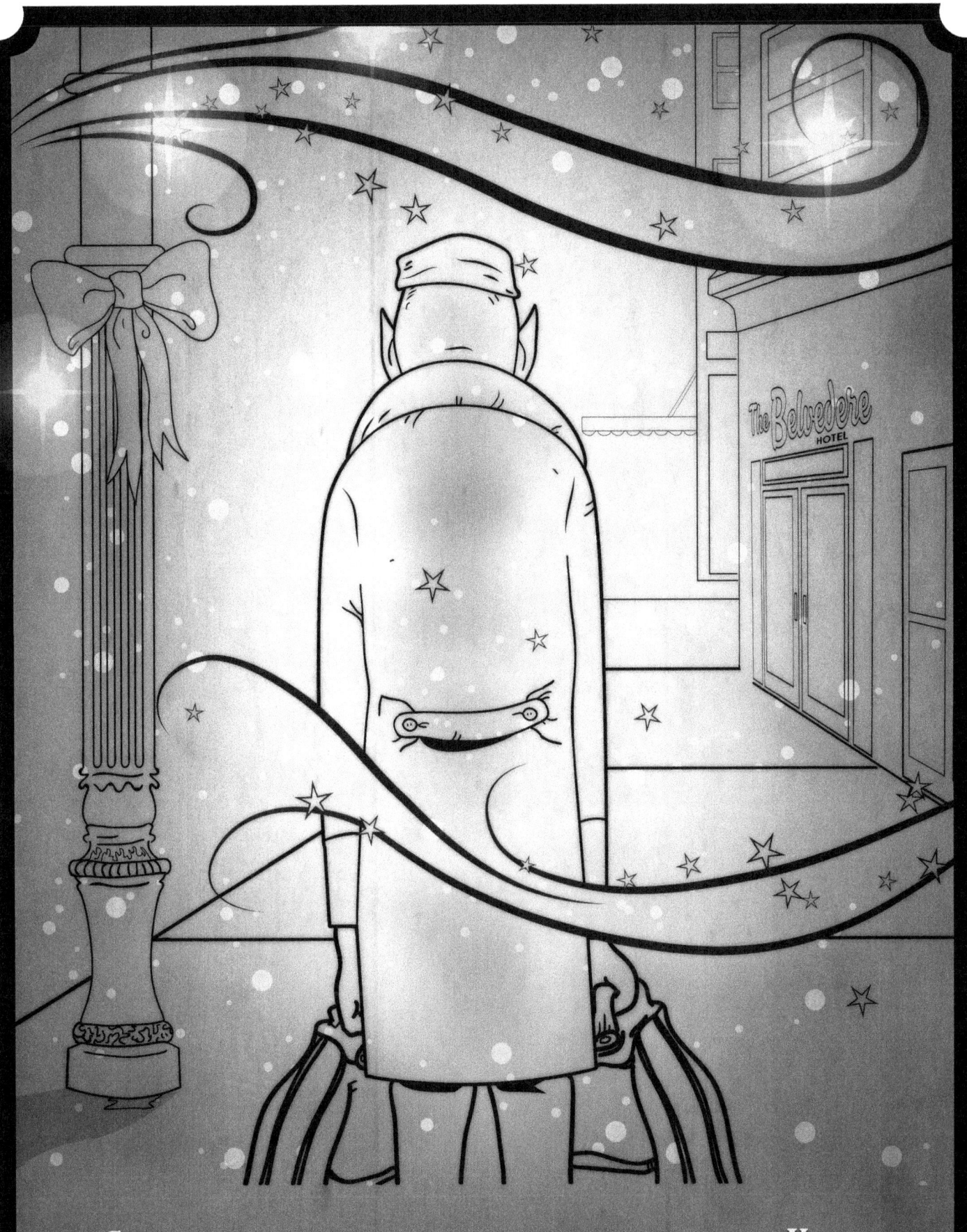

GRABBING HIS THINGS, HE RUSHED OFF TO HIS KEEP,
ADMIRING THE CITY THEY SAY DOES NOT SLEEP.

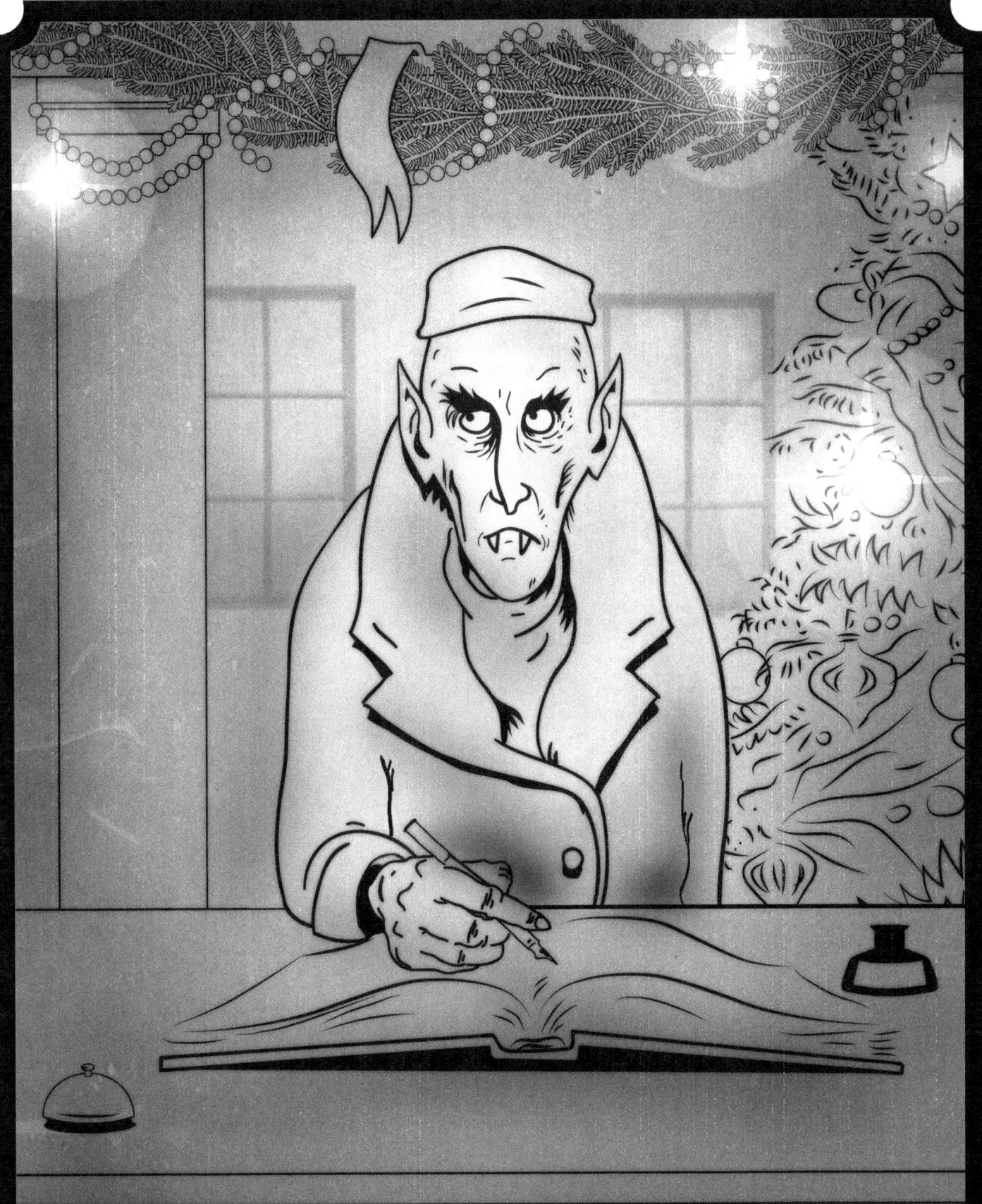

Now entering the lobby, he looked all around,
At the pretty bright tinsel and lights that abound.

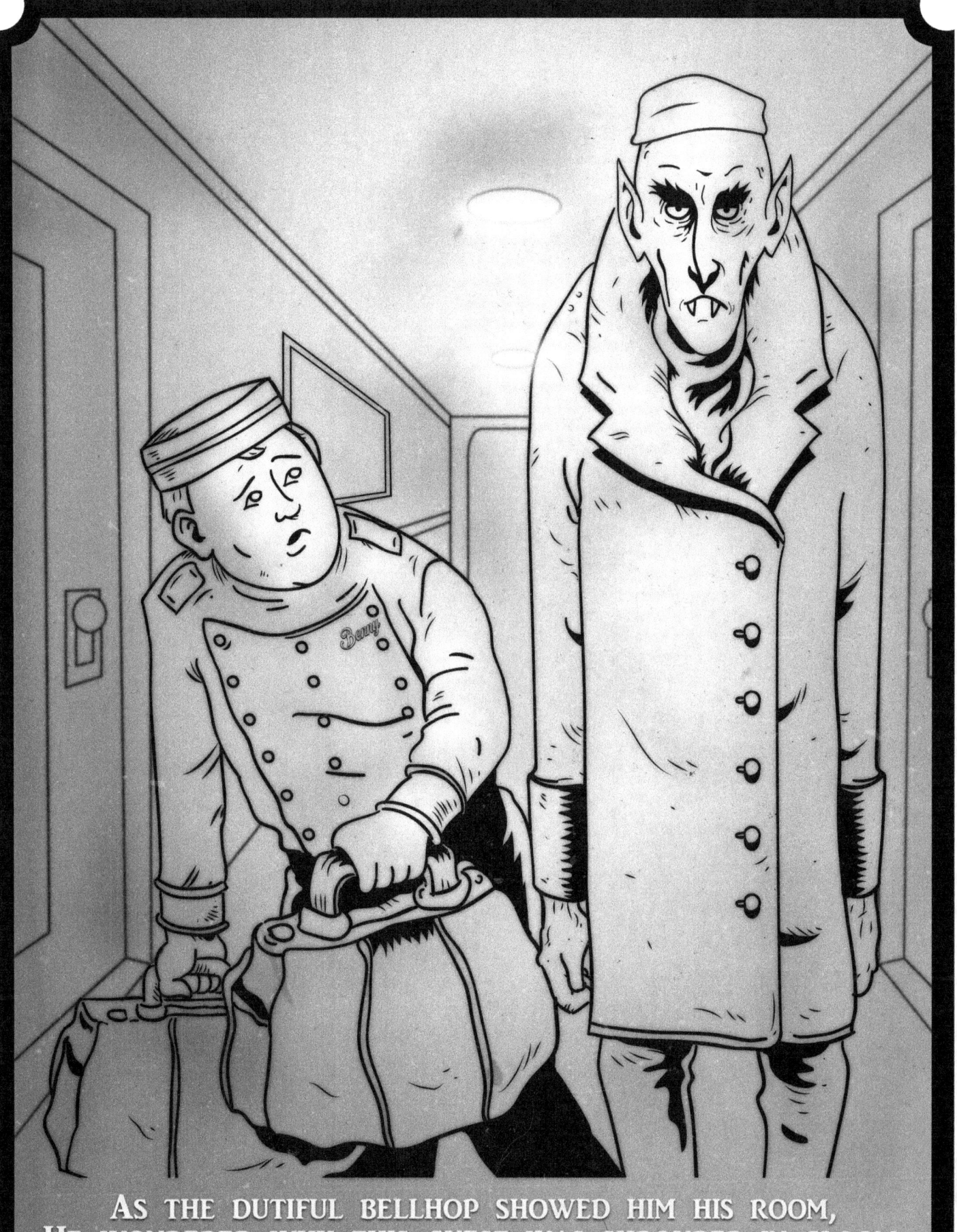
As the dutiful bellhop showed him his room, he wondered why this guest was shrouded in gloom.

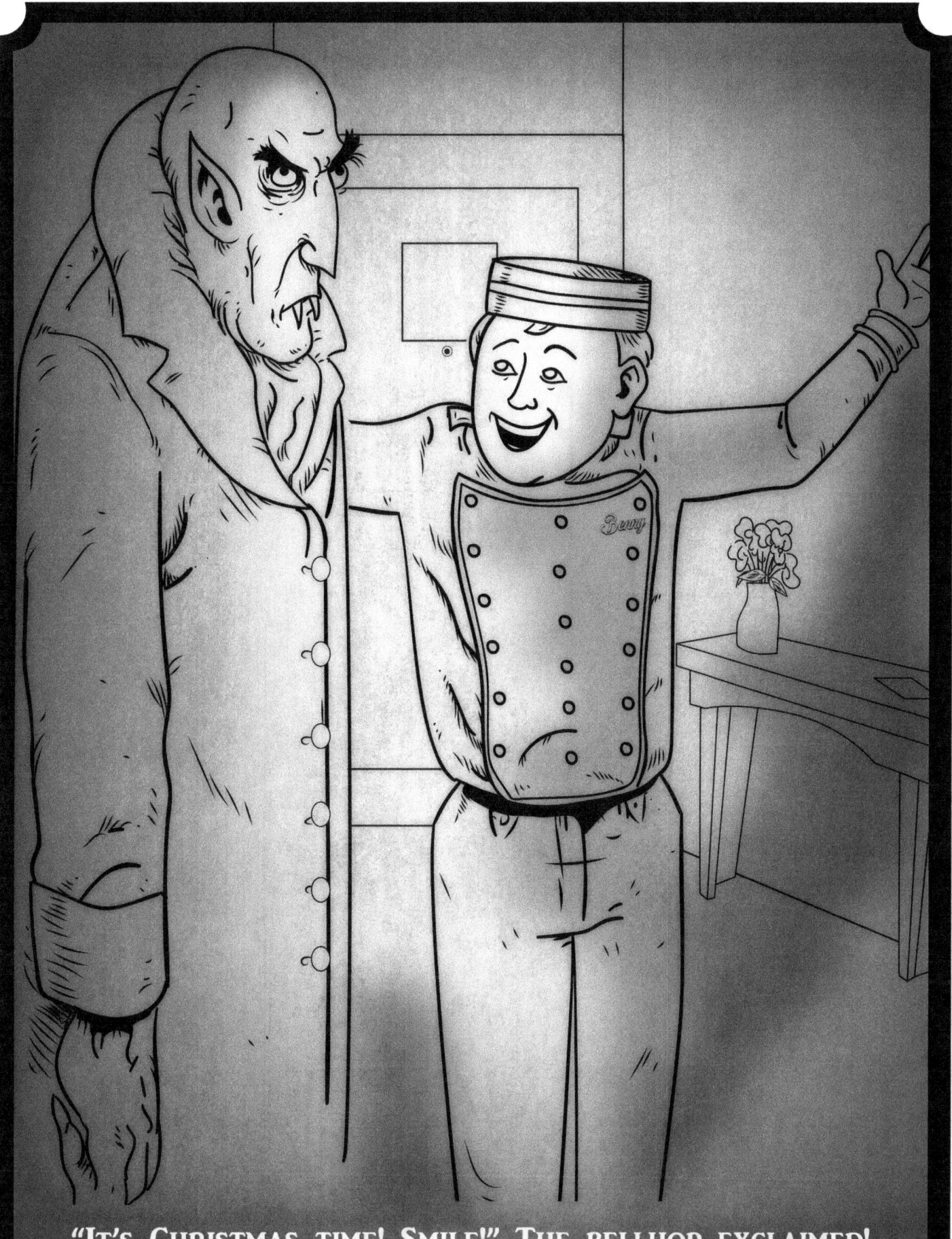

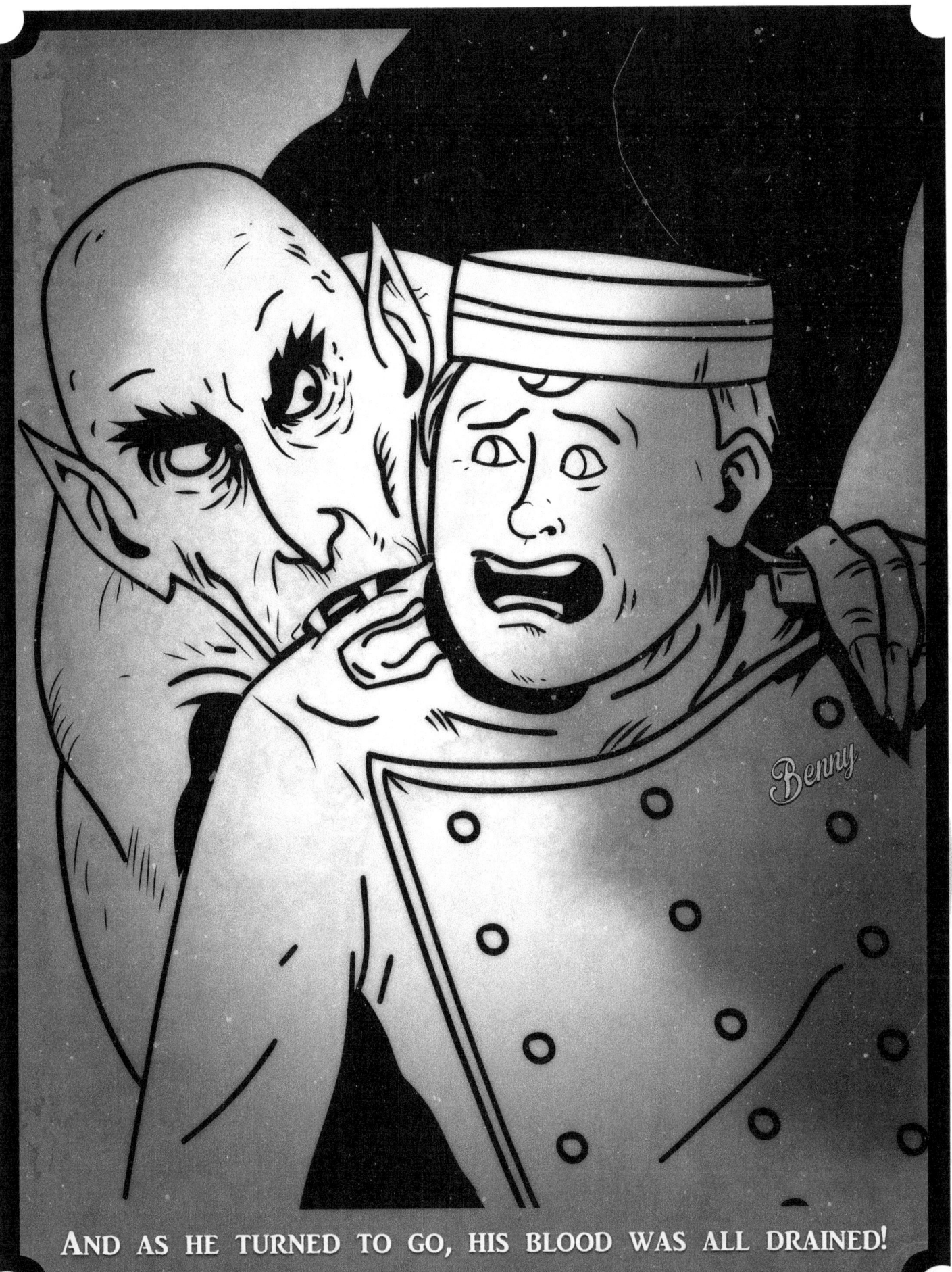

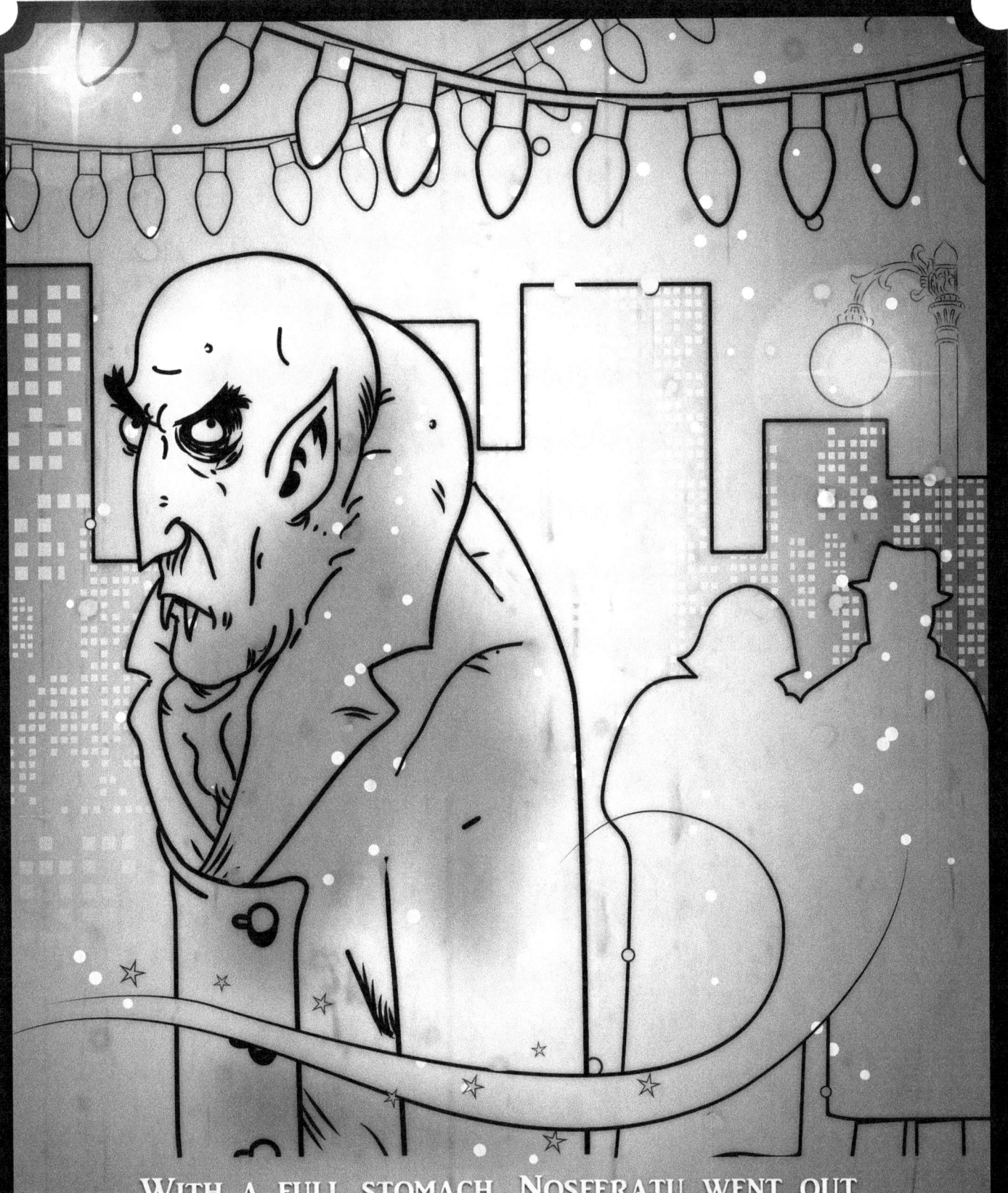

With a full stomach, Nosferatu went out,
"This city is marvelous, of that there's no doubt!"

He strolled down the avenues covered in lights,
He admired the buildings of staggering heights.

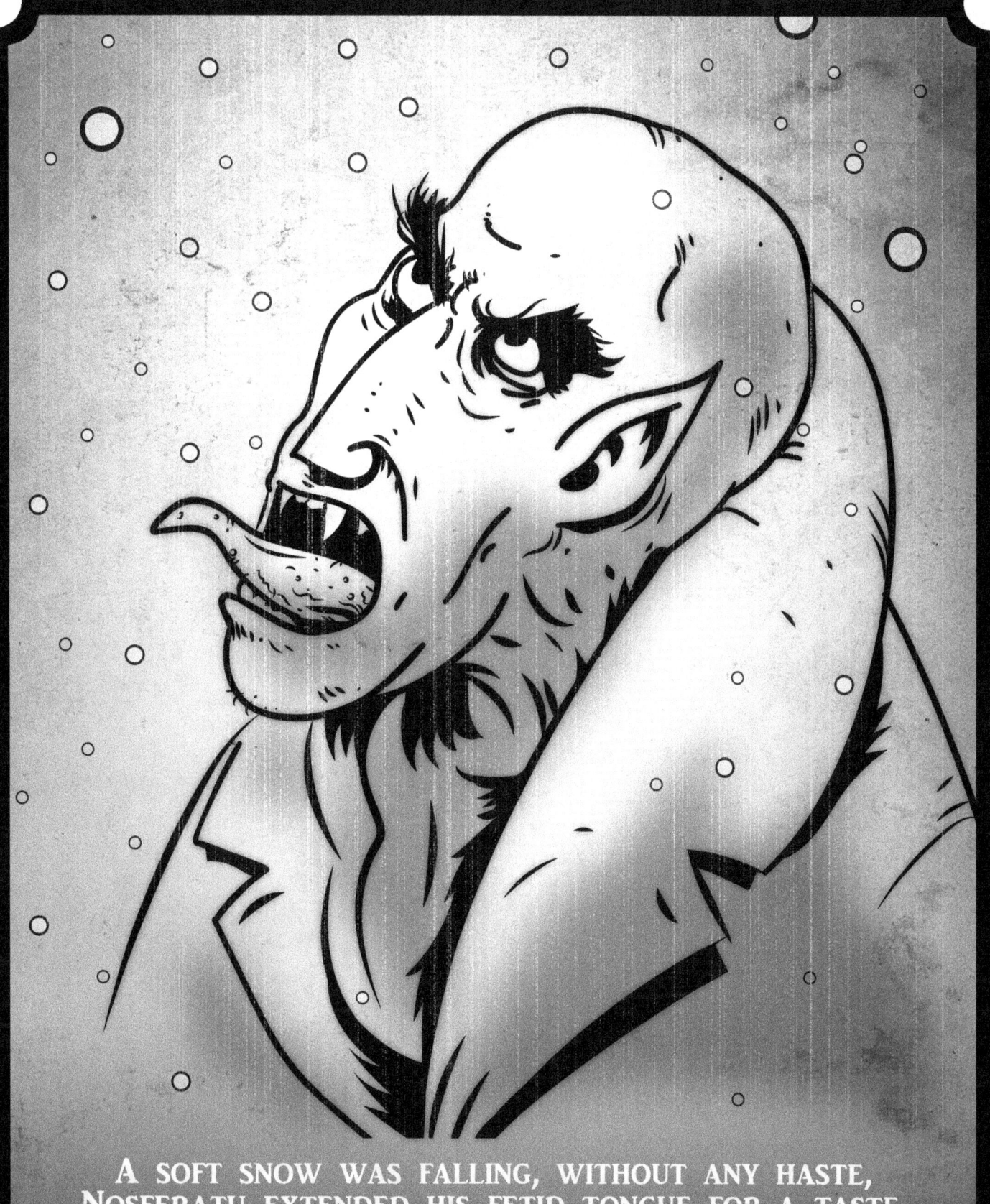

A soft snow was falling, without any haste,
Nosferatu extended his fetid tongue for a taste.

"Ech! I don't see a point to that, not at all!"
He then turned and looked for a victim to thrall.

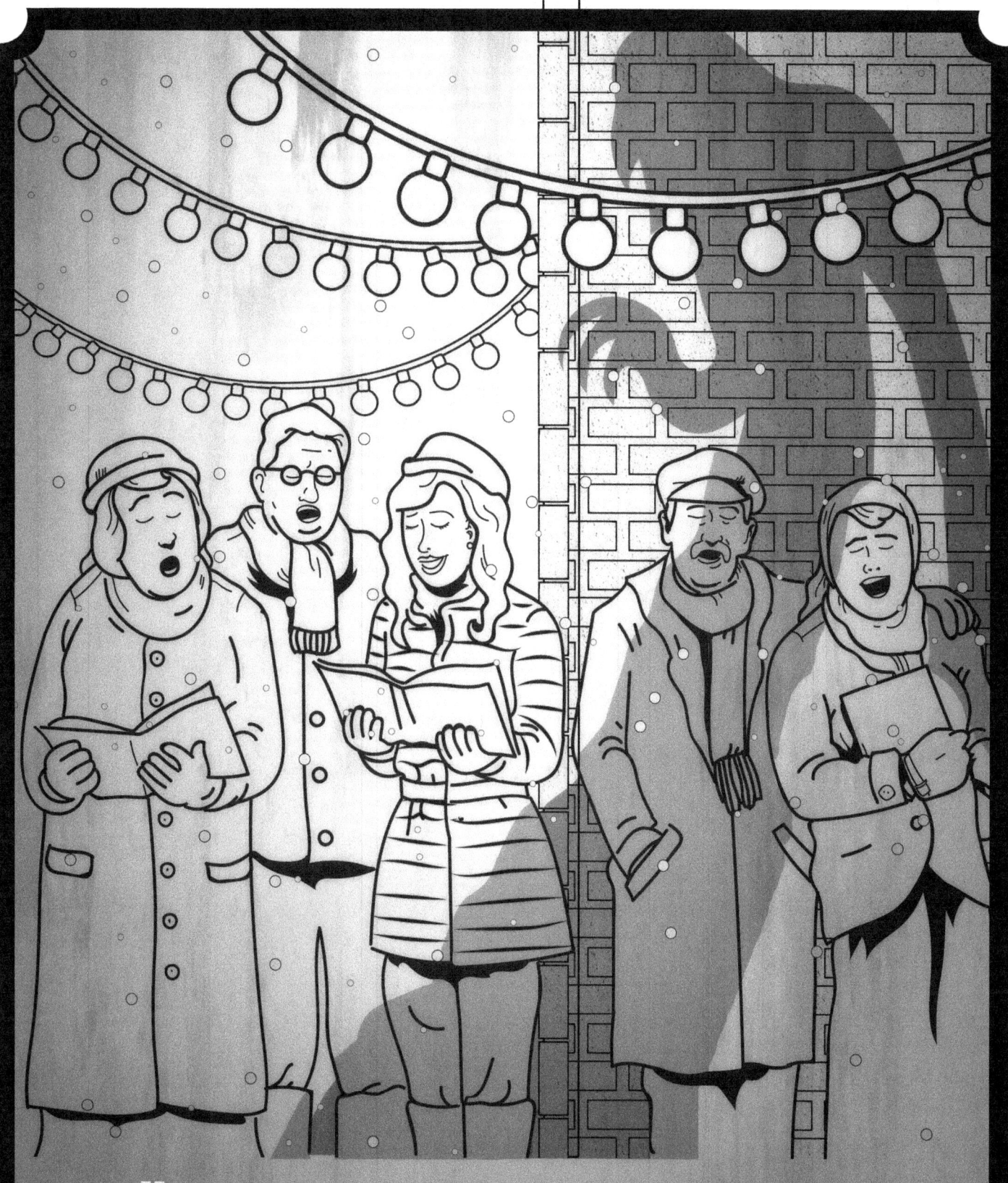

He found several of them standing in line,
Singing some carols and sounding quite fine.

They asked him to join them, he gladly agreed.
And stood by a woman with a jacket of tweed.

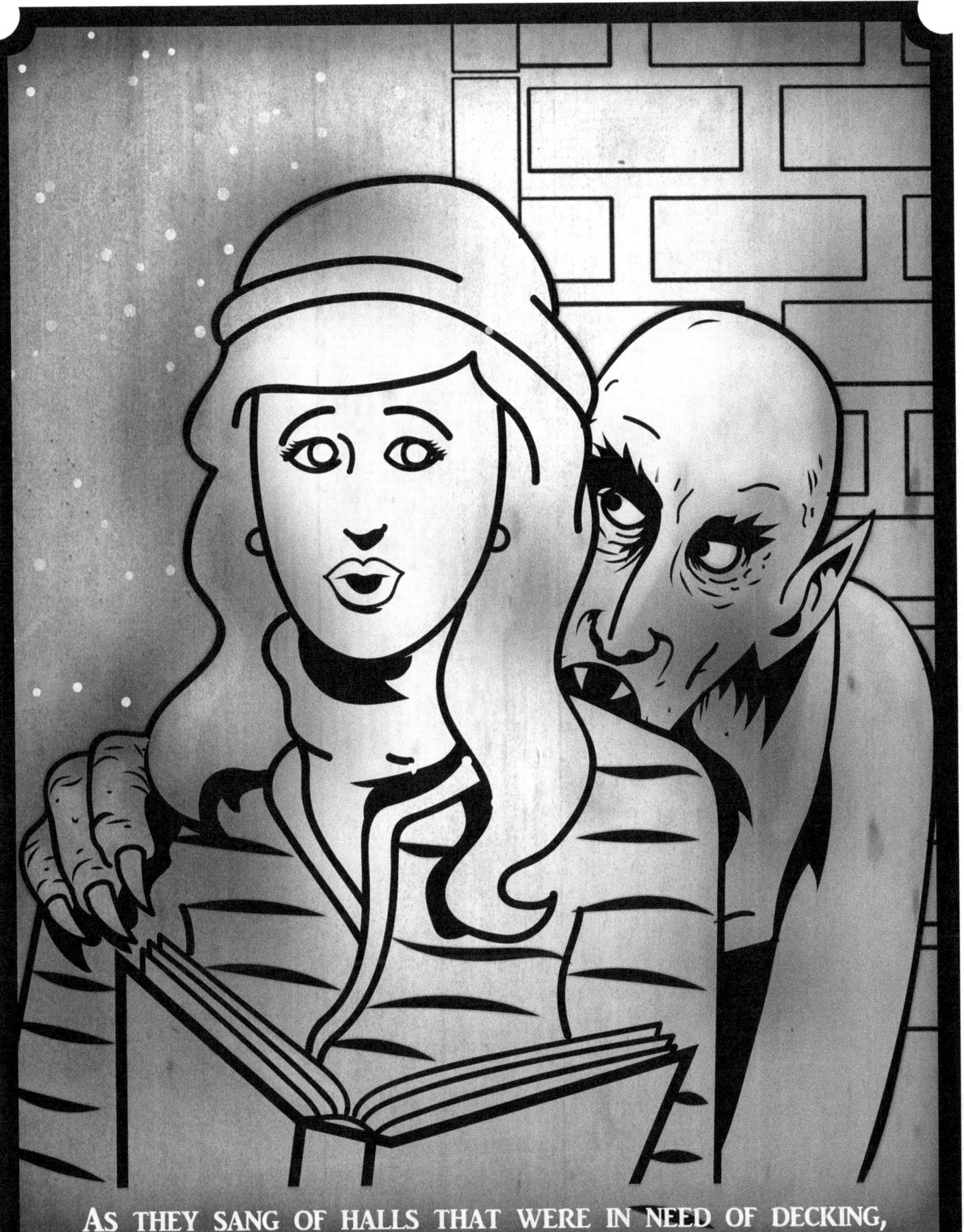

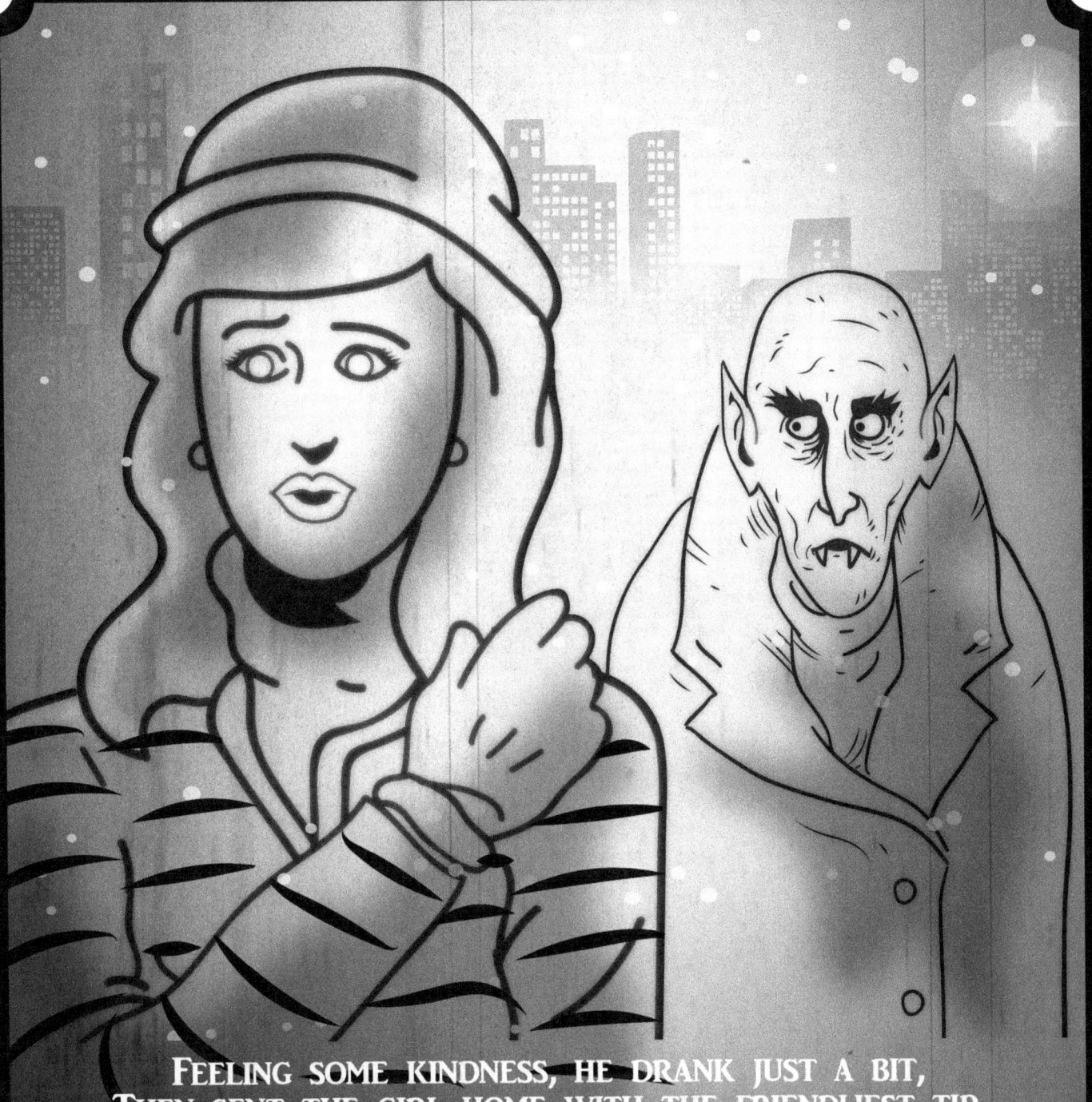

Feeling some kindness, he drank just a bit,
Then sent the girl home with the friendliest tip.

"Should you awaken tonight in a deep hunger fit,
Any morsel in your fridge should tame it a bit."

And as the girl walked away rubbing her shoulder,
He watched her go, longing to hold her.

"This City," he thought, "this Time of the year,
Is making me go soft, I'm beginning to fear."

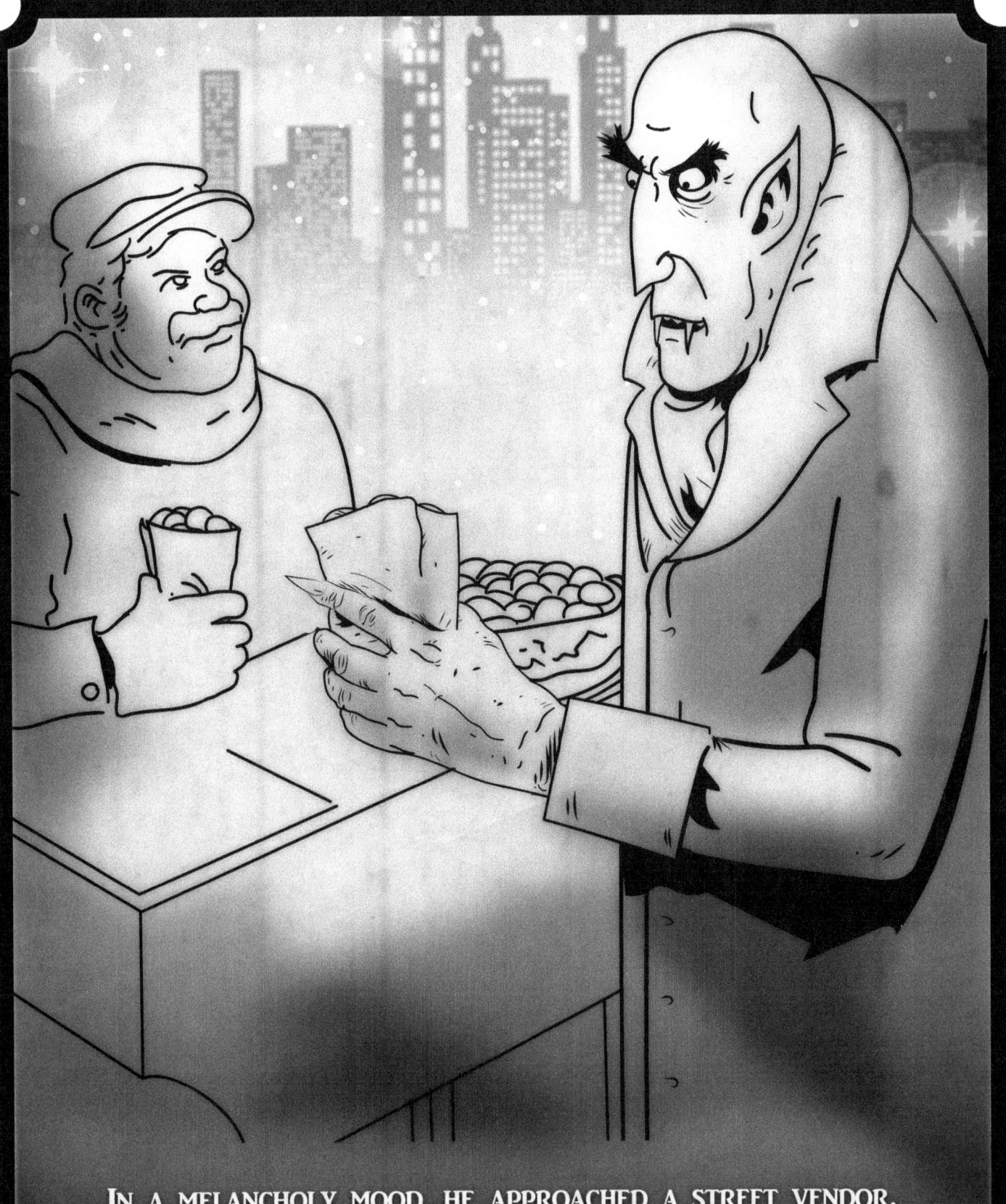

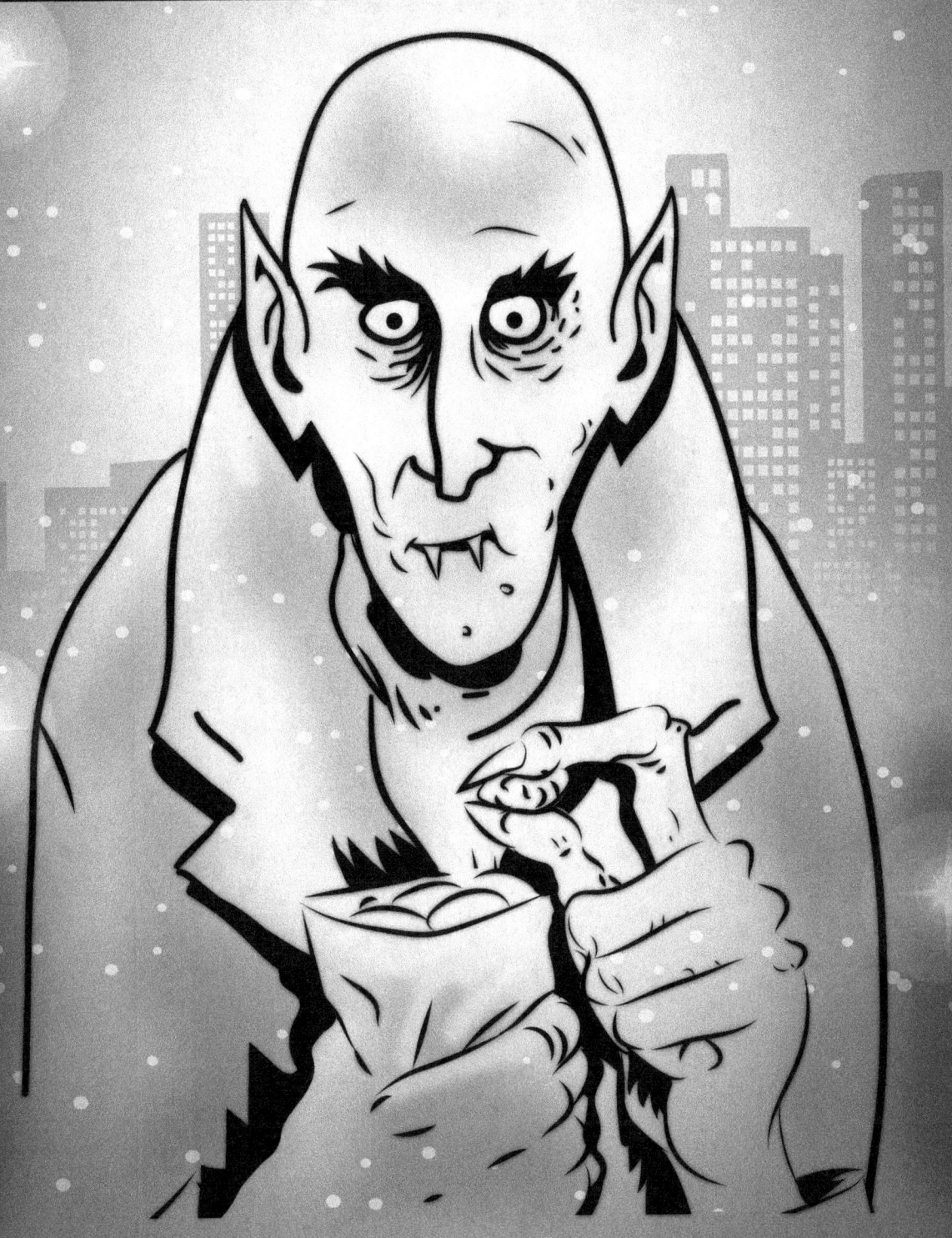

HE WALKED ALONG SNACKING FROM THE WARM BAG,
"QUITE LOVELY, THESE ARE," BUT HIS MOOD DID THEN SAG.

"THIS LIFE THAT I'M LEADING, GIVING BIRTH TO SUCH DREAR,
IN THE END LEAVES ME FEELING QUITE HOLLOW, I FEAR."

"I'VE DERIVED MUCH MORE PLEASURE FROM THESE HOLIDAY SIGHTS,
THAN FROM ALL MY DARK YEARS OF CAUSING THE FRIGHTS."

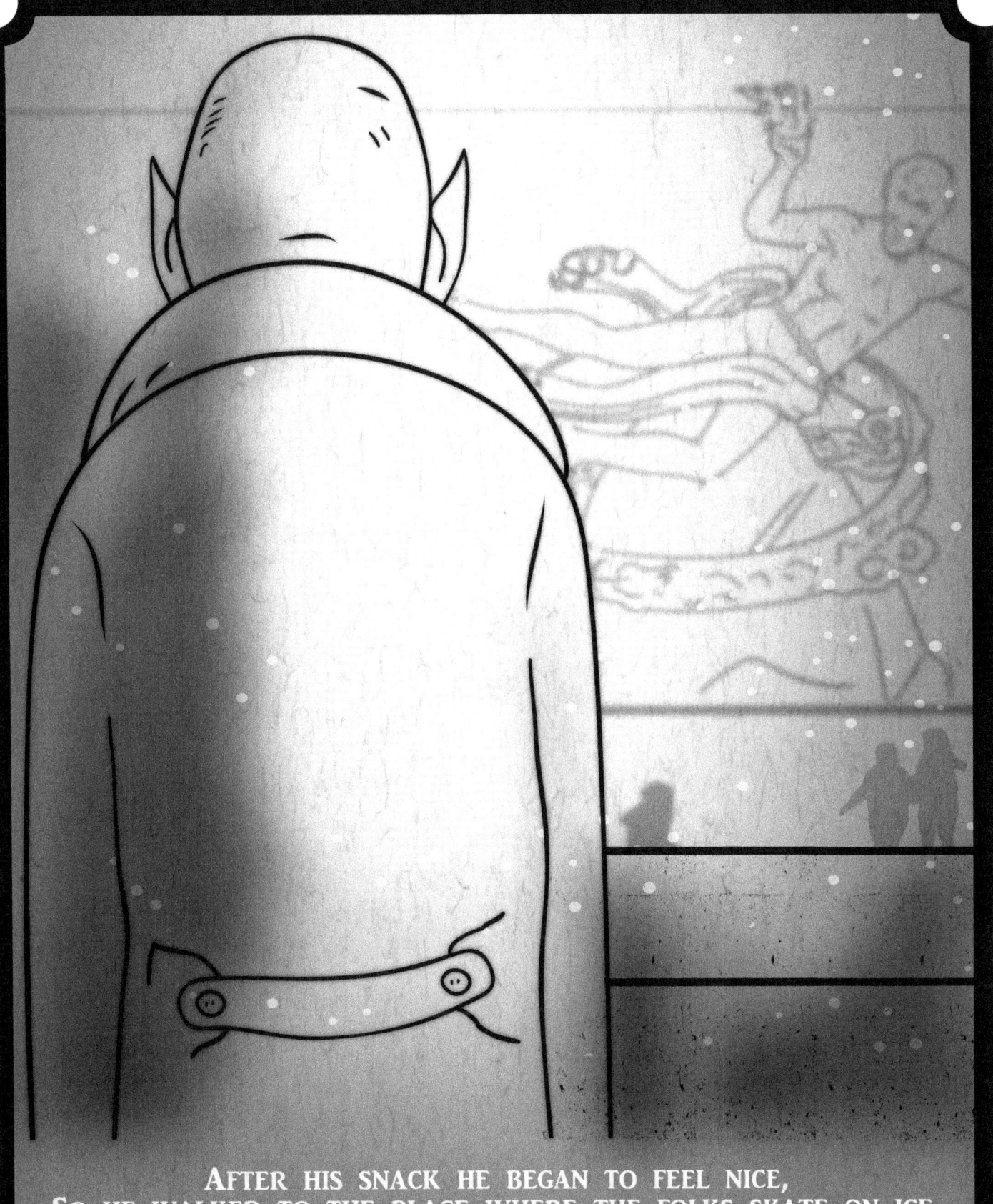

After his snack he began to feel nice,
So he walked to the place where the folks skate on ice.

He saw couples en masse holding hands as they glided,
Laughing and shrieking, they seem so delighted!

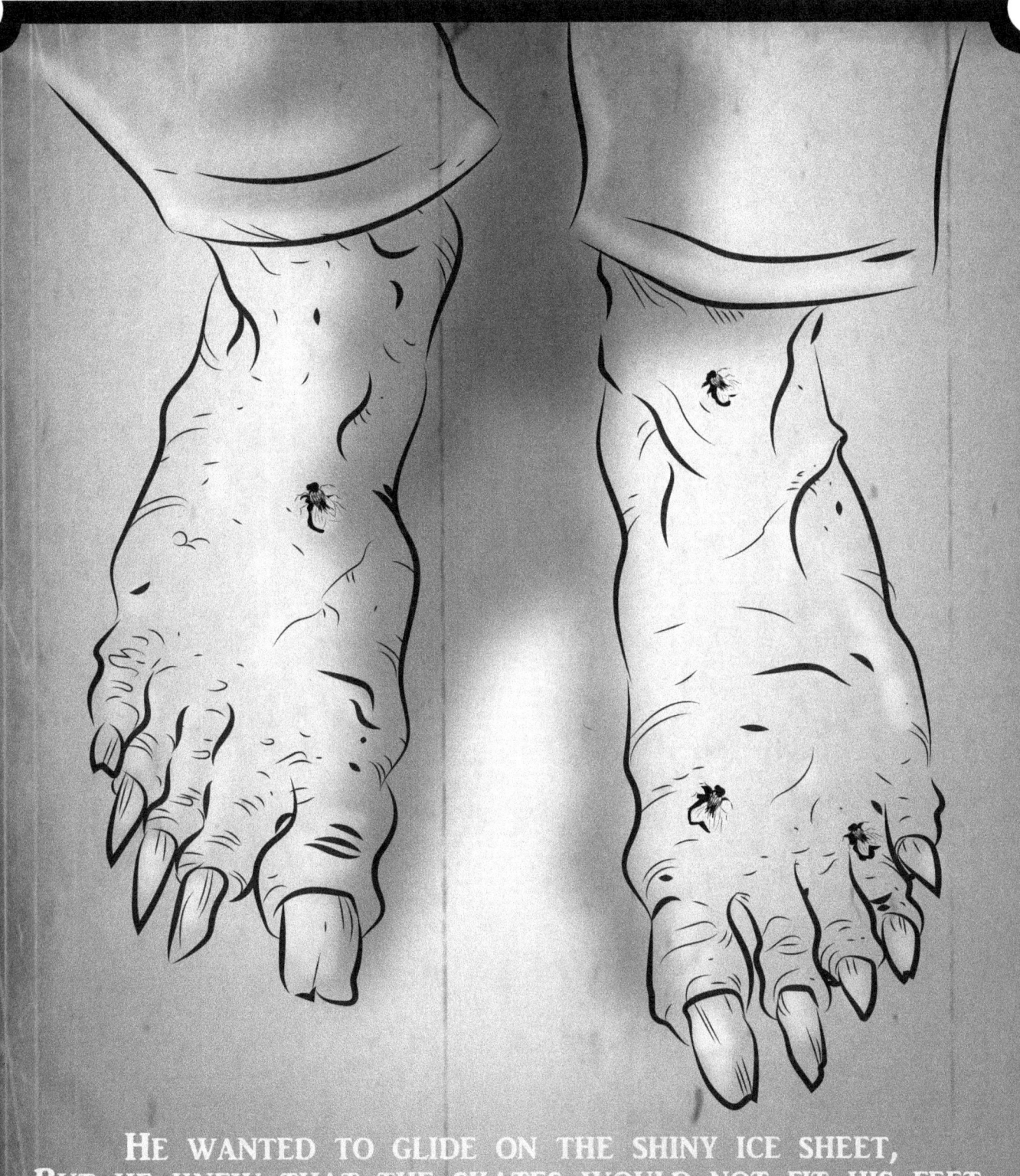

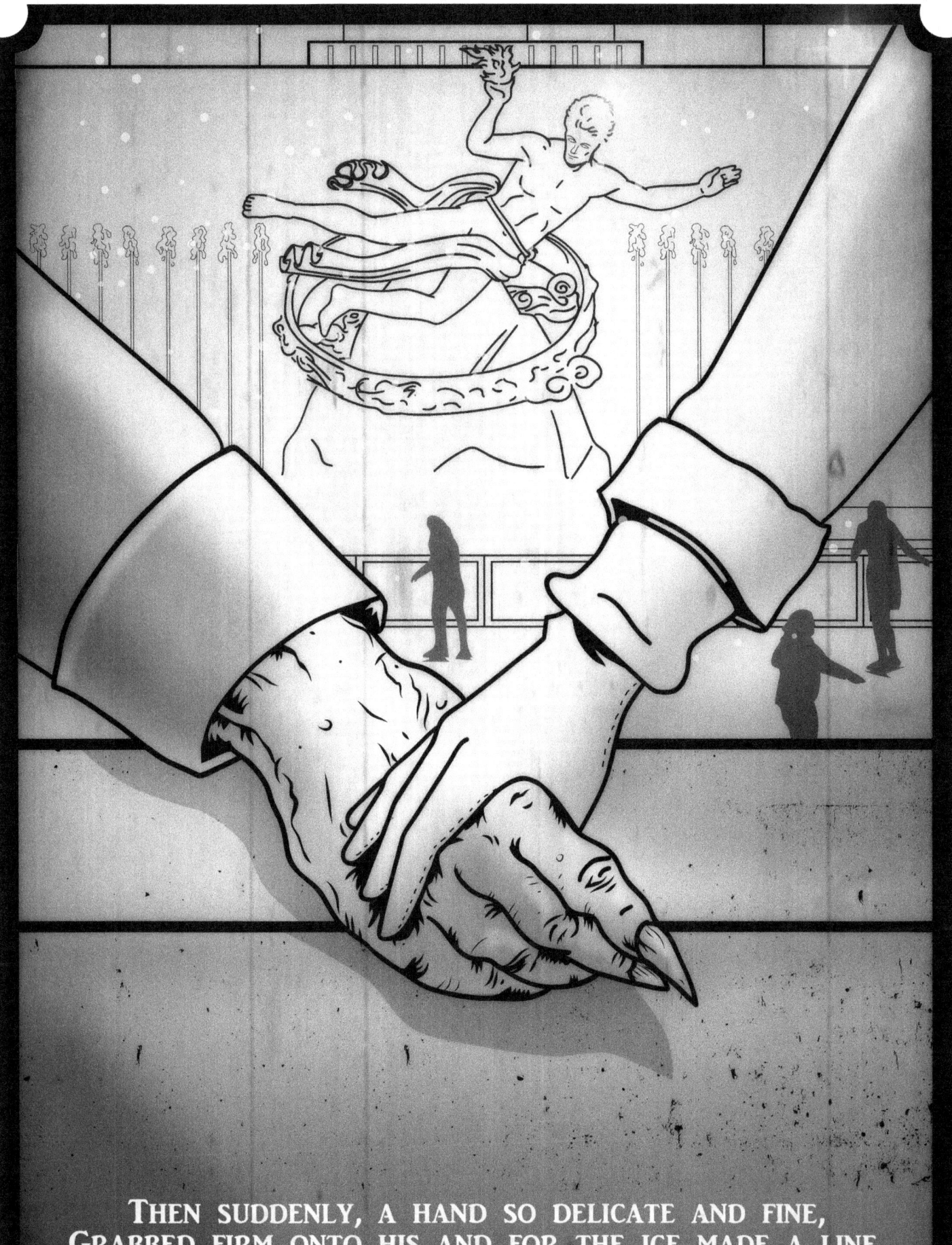

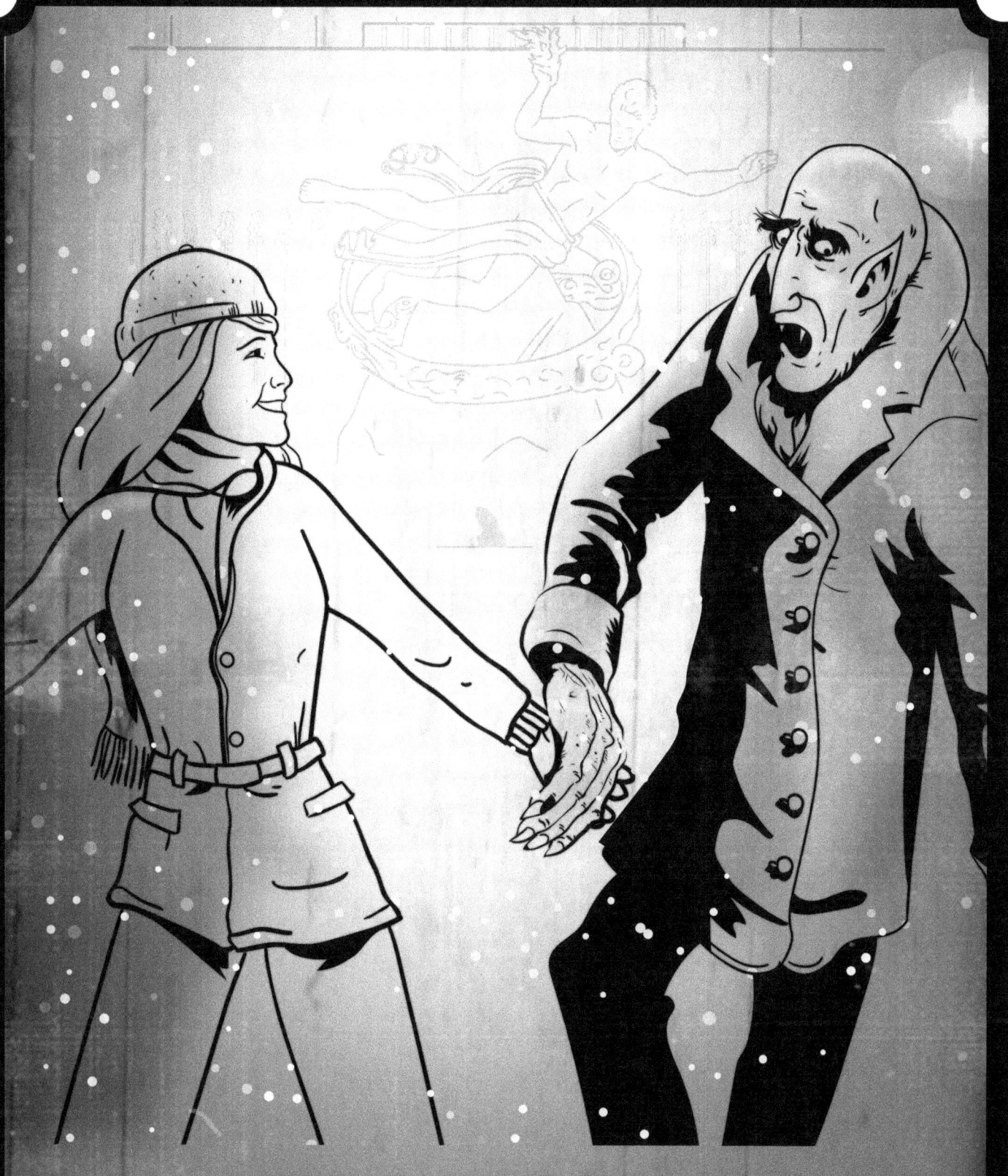

His first lap around was quite a bumpy ride,
He stumbled and bumbled and fell thrice on his side.
But before he knew it he was circling the rink,
Skating and laughing and flushing light pink.

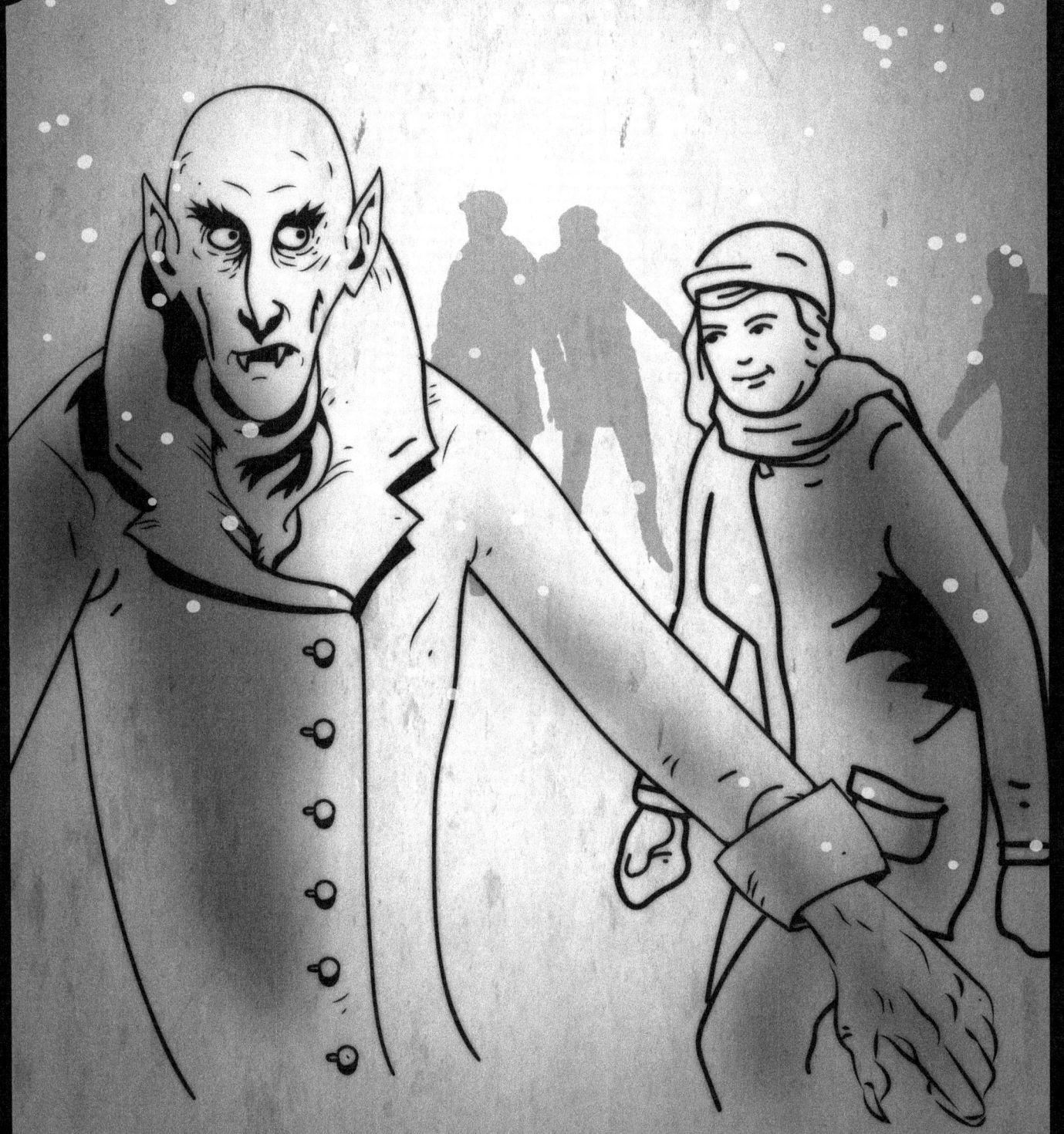

HE MADE SOME NEW FRIENDS AND THEY HAD QUITE A GAS,
"MERRY CHRISTMAS!" THEY'D SAY TO THOSE THEY DID PASS.

THEY SKATED FOR HOURS AND HAD MUCH FUN,
THEN WALKED THE STREETS, THIS NIGHT WAS NOT DONE!

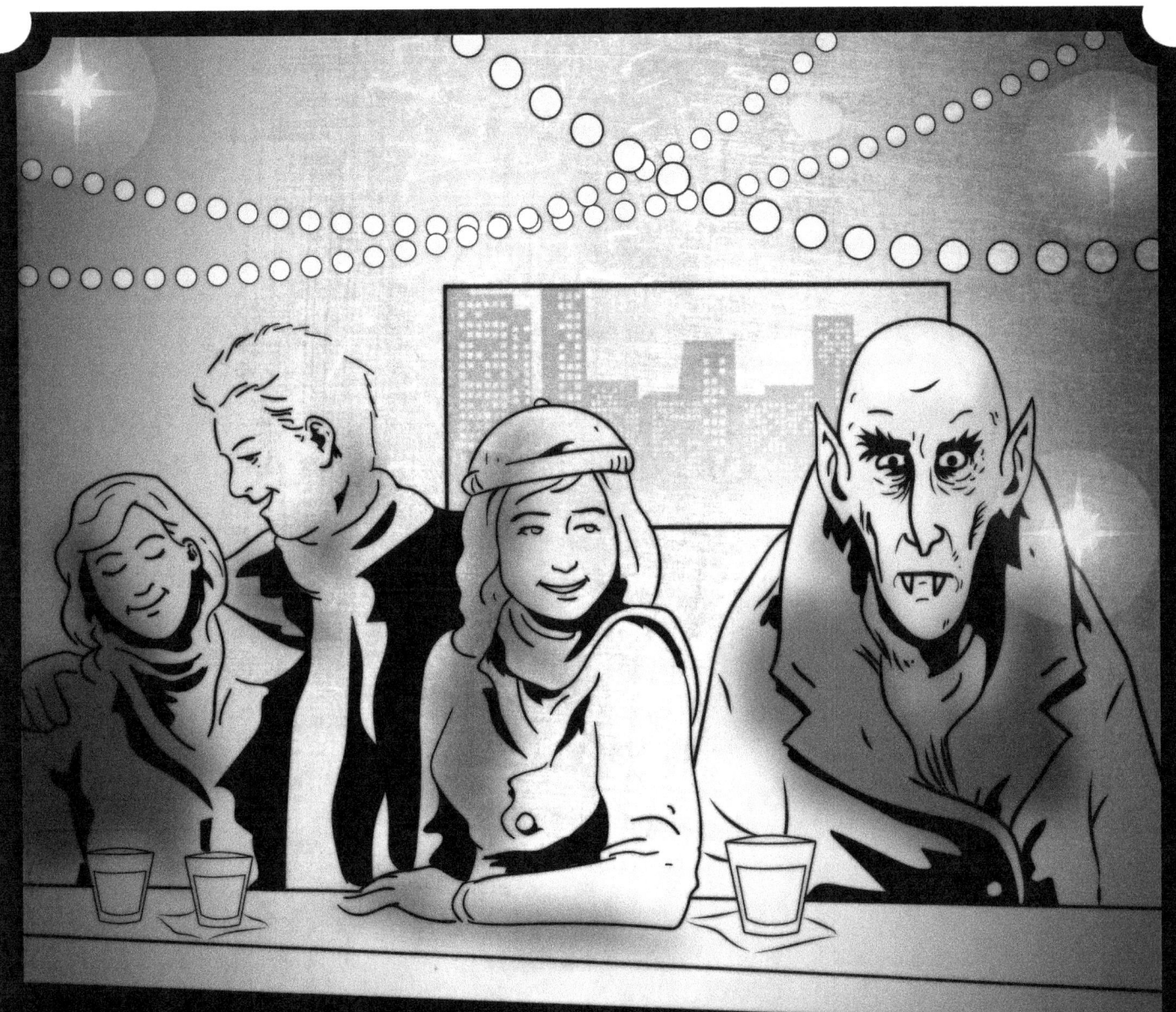

They stopped at a bar where he had a nice drink,
It warmed him inside and he started to think.

"These people, this city, so unlike what I've known,
And yet they welcome me as if I'm one of their own."

"Should I stay, try a new way of life for a bit?"
A change would serve him well, he had to admit!

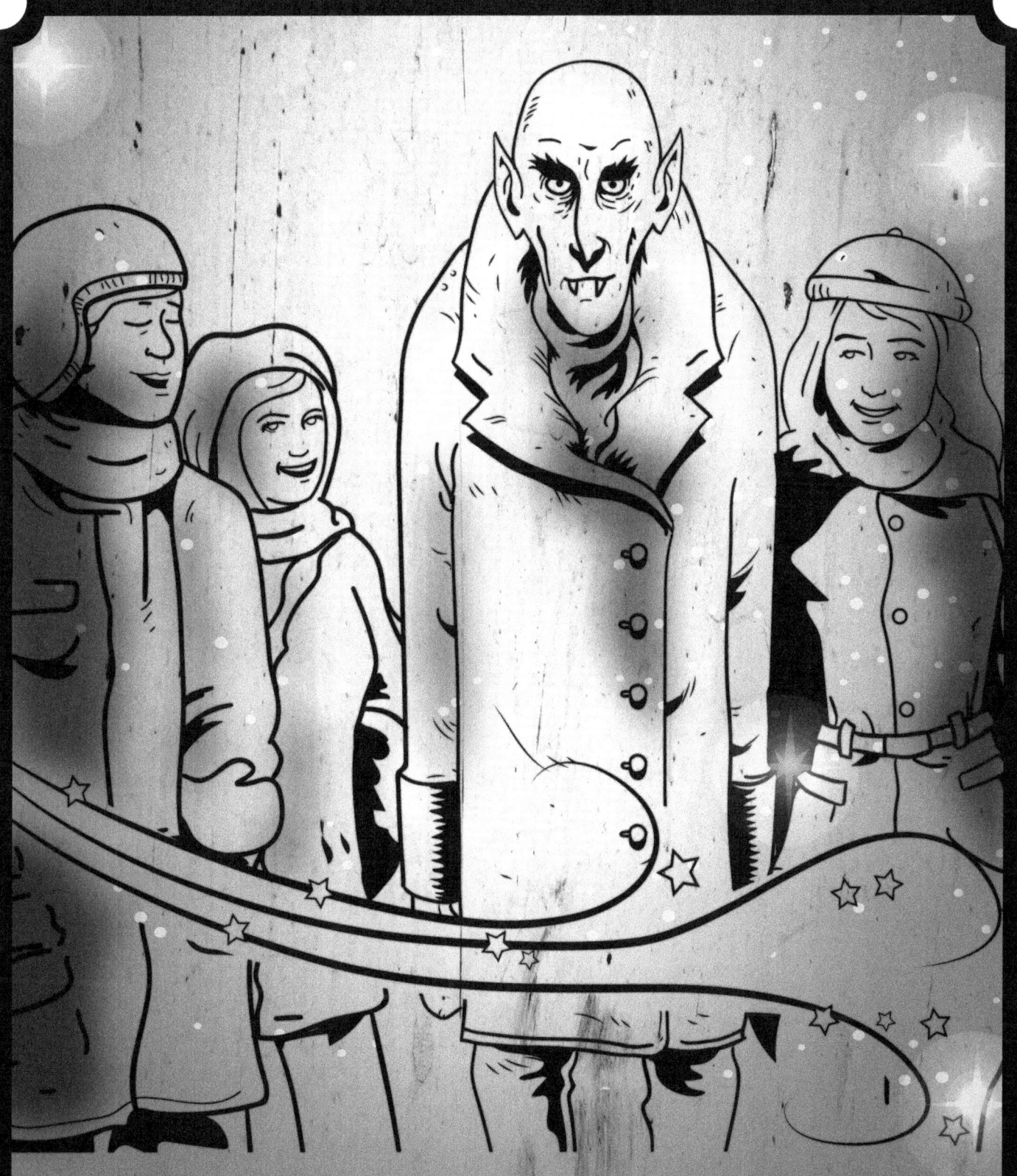

As they ventured out again for another bit of walking,
He'd made up his mind, no more people stalking!

"I'll move to this city, make friends, start anew,
I'll turn a new leaf, yes! That's what I'll do!"

So they walked a bit further and took in more sights,
And in the end Nosferatu treated them all to a bite!

End

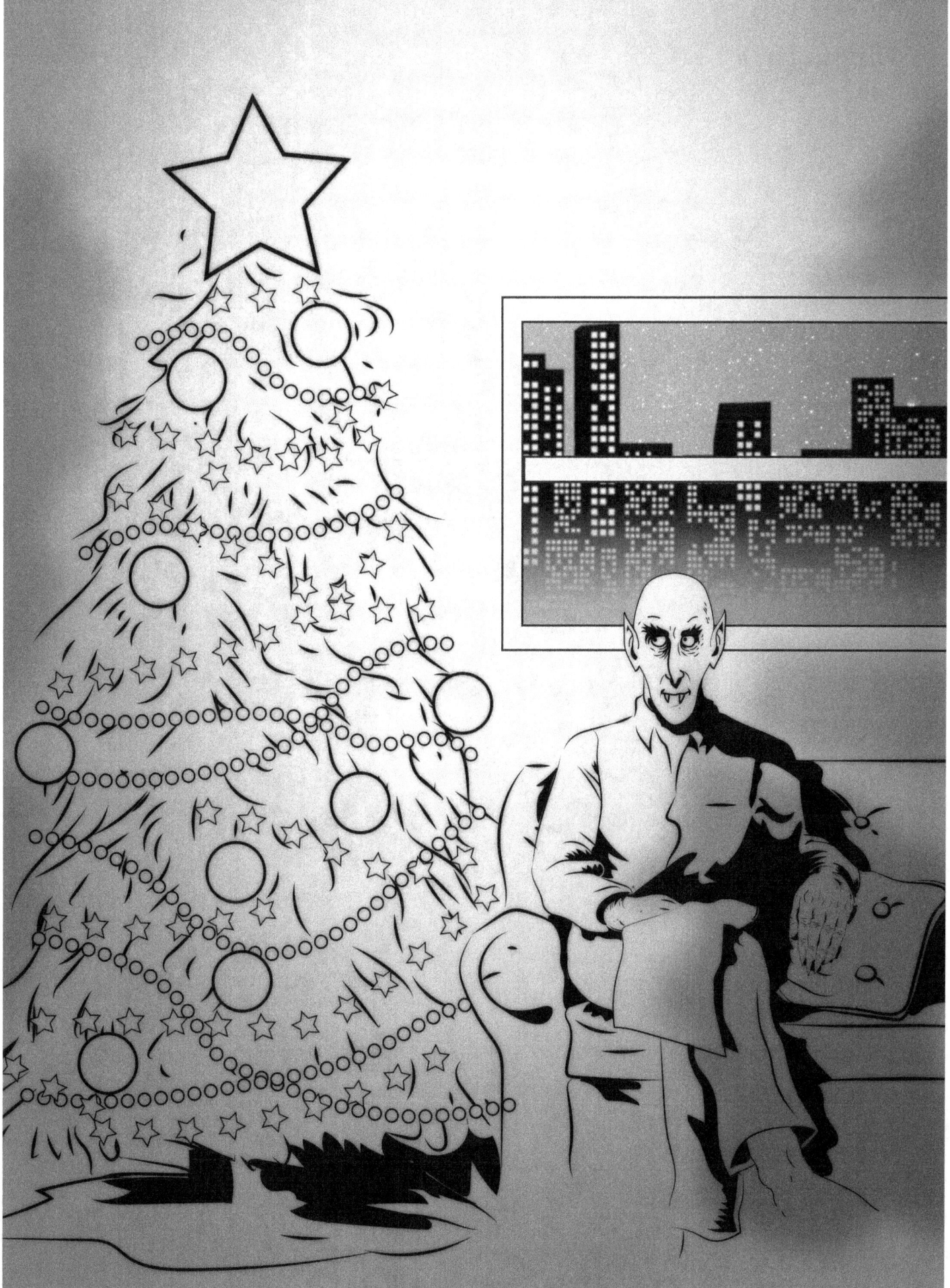

ABOUT THE ARTIST

Robert's imagination and desire to draw were first fueled by his frequent visits to the corner newsstand in his Brooklyn neighborhood to purchase comic books, especially those that featured the art of Neal Adams, George Perez, and Jim Aparo. Later, the films seen on local TV, everything from the comedies of Abbott & Costello and The Marx Brothers, B Monster movies and especially the Planet of the Apes series, left a definite imprint in his work. More recently, an interest in Tiki and Pulp Art have been added to the mix. Incorporating an ever-growing cast of Apes, Tikis and appearances from the likes of Doc Savage, Tarzan, The Shadow and more. He is creating a unique narrative through his paintings and sculptures.

Robert's work has appeared on album covers, in publications such as Tiki Magazine and Pinstriping & Kustom Graphics Magazine, and has shown in galleries including Disneyland's Wonderground, Harold Golen, M Modern, Creature Features and Bear & Bird among others. You can also see Robert's work in trading card sets for Topps, Cryptozoic, and Upper Deck on licenses such as Garbage Pail Kids, Wacky Packages, Mars Attacks, Star Wars, DC Comics, Marvel Comics, Ghostbusters, Adventure Time and more. Most notably, Robert worked on 8 paintings for the Upper Deck trading card set FIREFLY The Verse.

Robert is also the author and illustrator of the books: STRANGEWISE NO.9 and CHIMPS & TIKIS AND RAVEN-HAIRED BEAUTIES: AN ADULT COLORING BOOK.

Find more of Robert's work at zerostreet.com or on Twitter, Instagram, Tumblr and Facebook by searching Zerostreet.

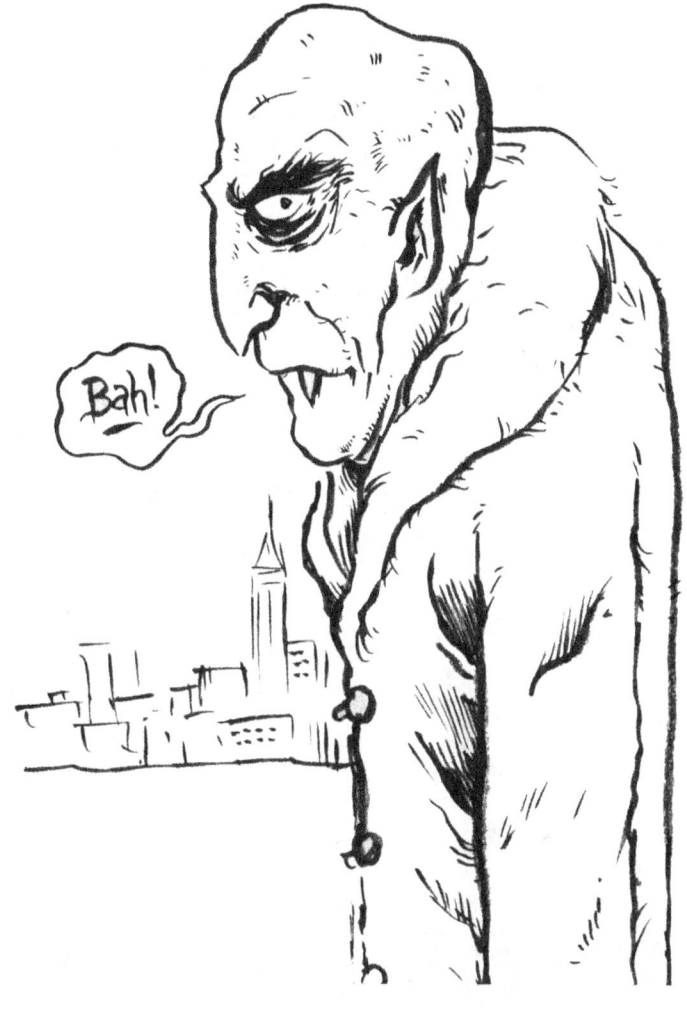

OTHER BOOKS BY ROBERT JIMÉNEZ

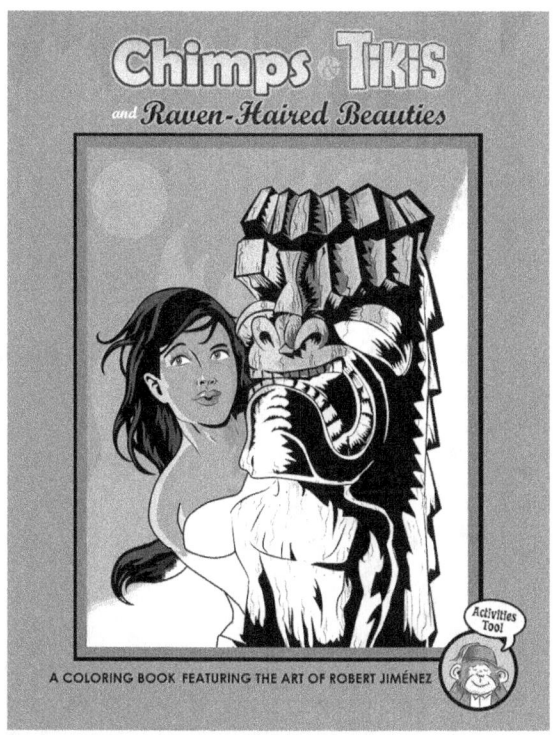

**CHIMPS & TIKIS AND
RAVEN-HAIRED BEAUTIES**
ISBN-13: 978-1533469724

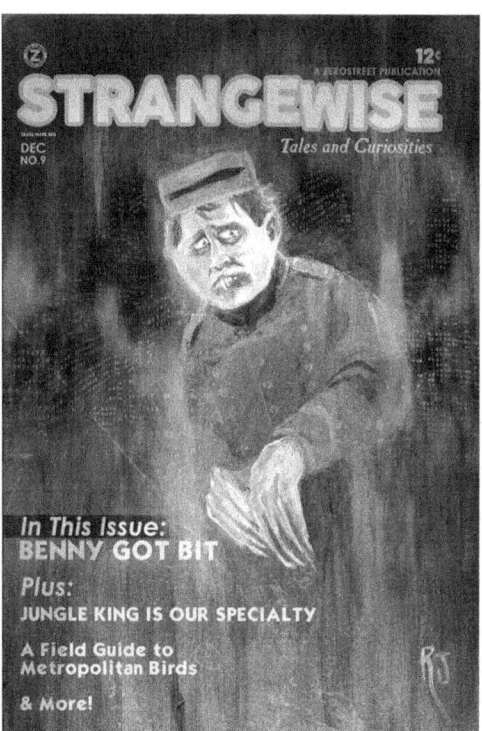

STRANGEWISE NO.9
ISBN-13: 978-1530548408

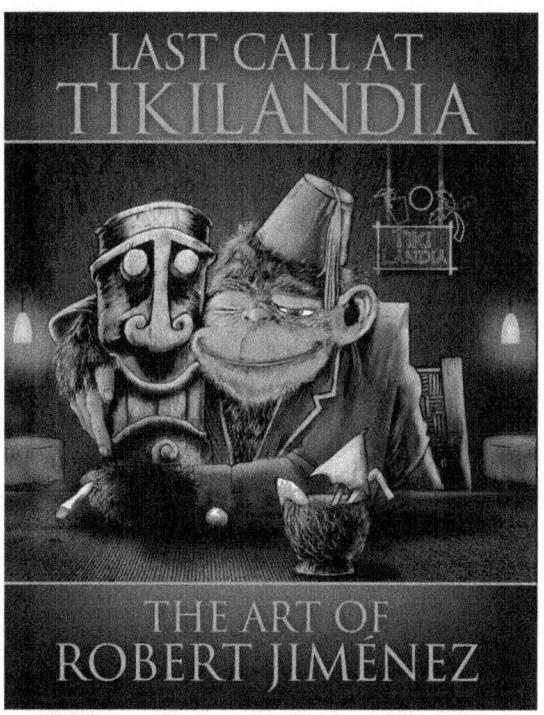

**LAST CALL AT TIKILANDIA
THE ART OF ROBERT JIMÉNEZ**
ISBN-13: 978-1463568627